P9-BJX-192

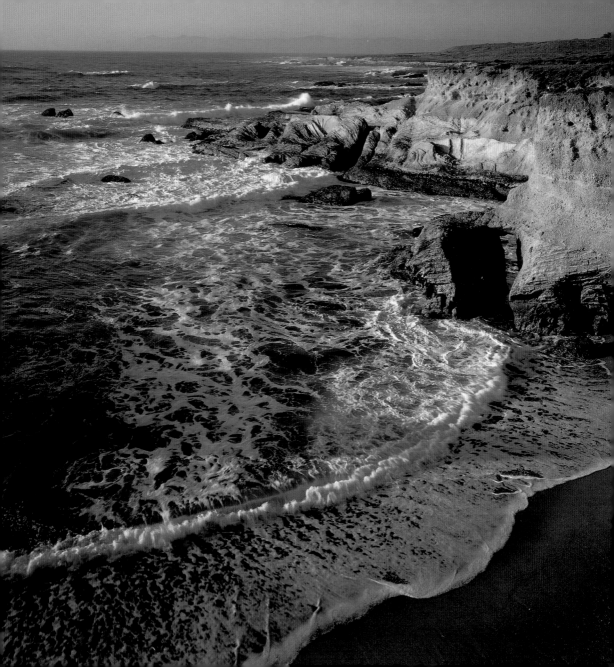

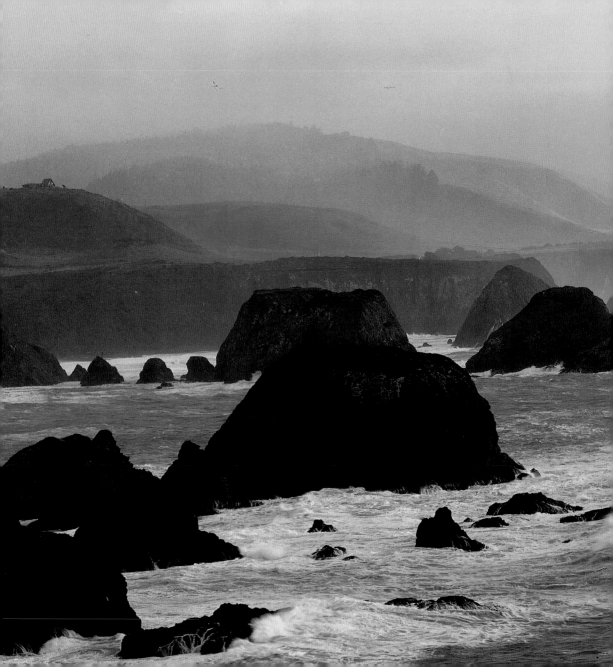

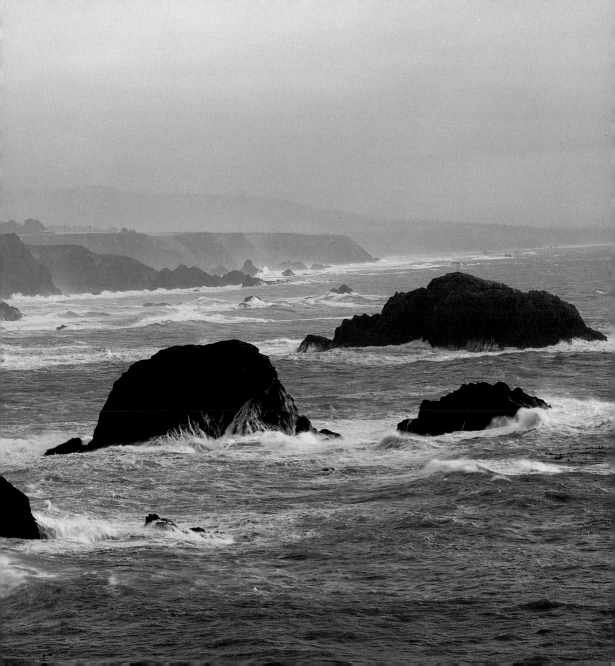

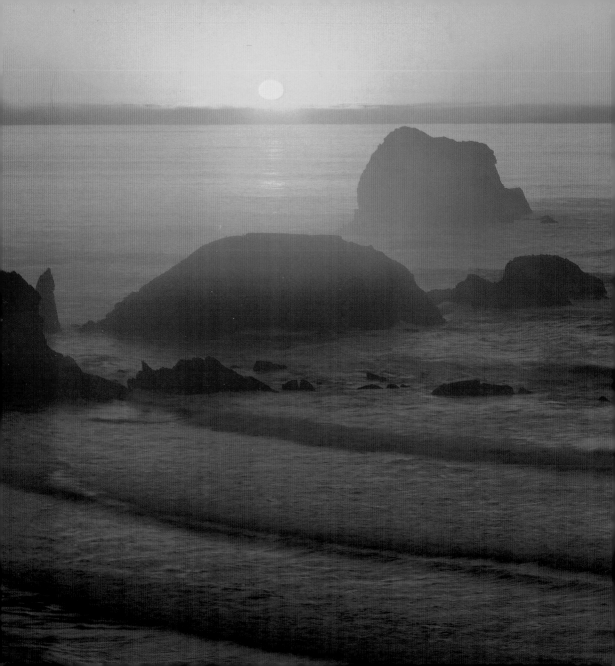

CALIFORNIA COAST

Photography by Carr Clifton
With Selected Prose & Poetry

California Littlebooks

Westcliffe Publishers, Inc., Englewood, Colorado

First frontispiece: Seaside bluffs, Montaña de Oro State Park
Second frontispiece: Coastline near the town of Elk, Mendocino County
Third frontispiece: Sunset at Sand Dollar Beach, near Monterey
Opposite: High tide, Salt Point State Park

International Standard Book Number: 1-56579-136-3
Library of Congress Catalog Number: 95-62432
Copyright Carr Clifton, 1996. All rights reserved.
Published by Westcliffe Publishers, Inc.
2650 South Zuni Street, Englewood, Colorado 80110
Publisher, John Fielder; Editor, Suzanne Venino; Designer, Amy Duenkel
Printed in Hong Kong by Palace Press

No portion of this book, either photographs or text, may be reproduced
in any form without the written permission of the publisher.

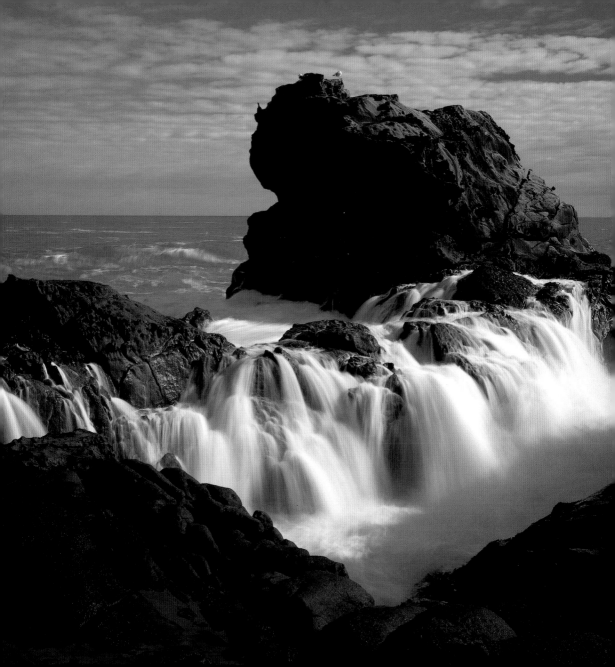

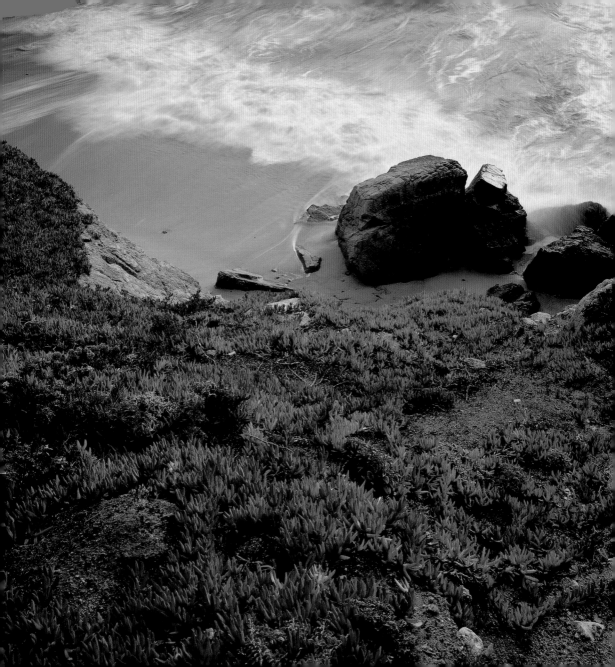

PREFACE

"The country here for several miles is high table-land, running boldly to the shore, and breaking off in a steep hill, at the foot of which the waters of the Pacific were constantly dashing. For several miles the water washes the very base of the hill, or breaks upon ledges and fragments of rocks which run out into the sea. Just where we had landed was a small cove....we strolled about, picking up shells, and following the sea where it tumbled in, roaring and spouting, among the crevices of the great rocks....there was a grandeur in everything around, which gave almost a solemnity to the scene: a silence and solitariness which affected everything! Not a human being but ourselves for miles; and no sound heard but the pulsations of the great Pacific!"

Published in 1946, Richard Henry Dana's description of the California coast in his book *Two Years Before the Mast* is as true today as it was a half century ago, for the thin strip of land where the continent meets the sea is an elemental landscape. Yes, the beaches shift and move according to the whims of the weather, and, yes, people continually crowd the ocean front with houses and amusements, yet it is also possible to escape the crowds, to find a spot of beach that is solitary, where the only sound is the eternal pulsation of the ocean waves.

Life at the edge of the sea is a constant reminder that we are part of a much larger whole. Whether you contemplate a single grain of sand or ponder the unknown worlds of the ocean depths, the seacoast is a place for thoughtful reflection. Carr

Ice plants, Garrapata State Park

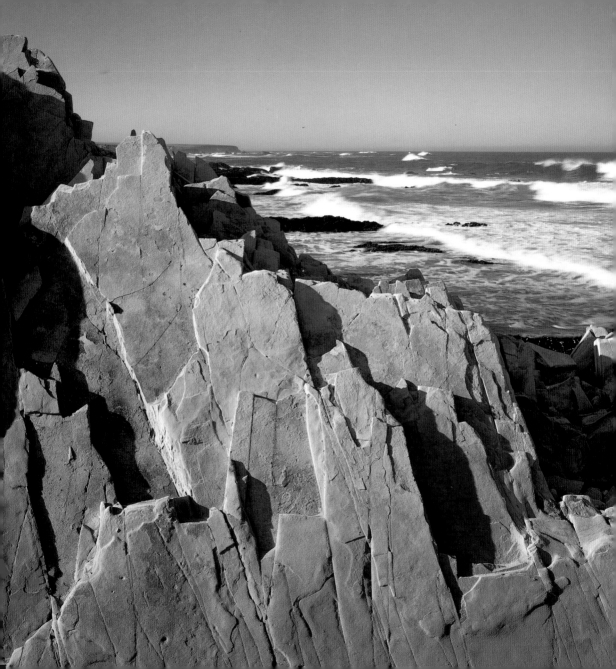

Clifton's photographs convey this, for his imagery is as timeless as it is dramatic.

Clifton captures the many moods of the California coast, moods that change with every hour of the day. Sunrise casts a luminescent glow on the Pacific. By mid-day, when the sun reaches its zenith, the coastline seems energized by the brilliant light. And at day's end, as the shadows grow long, the departing sun bathes the sea and the shore in a multitude of colors, from the vibrant yellows and oranges of sunset to the subdued pinks and purples of twilight.

The California coast is a place of many moods. Through Carr Clifton's photographs you can enjoy them all.

— Suzanne Venino
Editor

Rock formations, Montaña de Oro State Park

"My life is like a stroll upon the beach,
As near the ocean's edge as I can go."

— Henry David Thoreau,
My Life Is Like a Stroll Upon the Beach

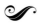

Sunset, Trinidad State Beach

"…while traveling through a region yet so little known, there was a pleasure to the novelty of exploration; and delays…afforded opportunities of indulging in predilections for natural study…especially the floral beauties of the hills."

— James Mason Hutchings, "Reminiscences of Mendocino," *Hutchings' California Magazine*, October 1858

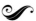

Coastal flowers, Mendocino Headlands State Park

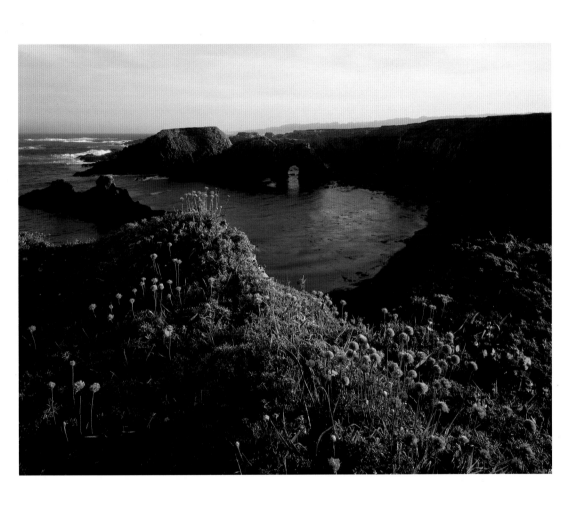

"Then on the shore
Of the wide world I stand alone, and
think
Till love and fame to nothingness do sink."

— John Keats, *When I Have Fears*

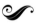

Low tide, Trinidad State Beach

"Nature is often hidden, sometimes overcome,

seldom extinguished."

— Francis Bacon, *Essays: Of Nature in Men*

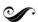

Cow parsnip, Monterey County

"We are as near to heaven by sea as by land."

— Humphrey Gilbert, *Voyages*

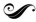

Surf along the Big Sur Coast

Overleaf: End of day, Salt Point State Park

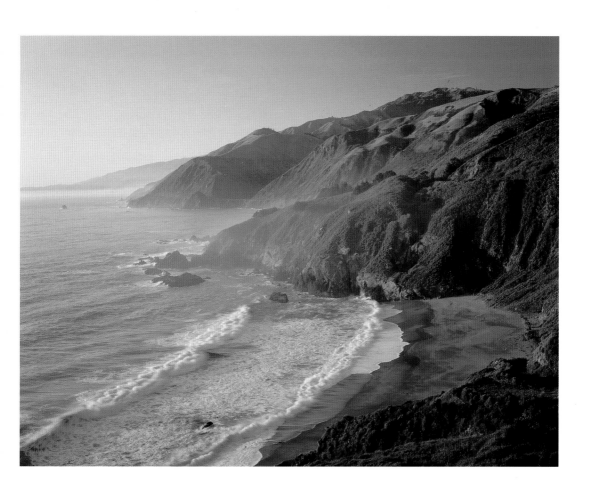

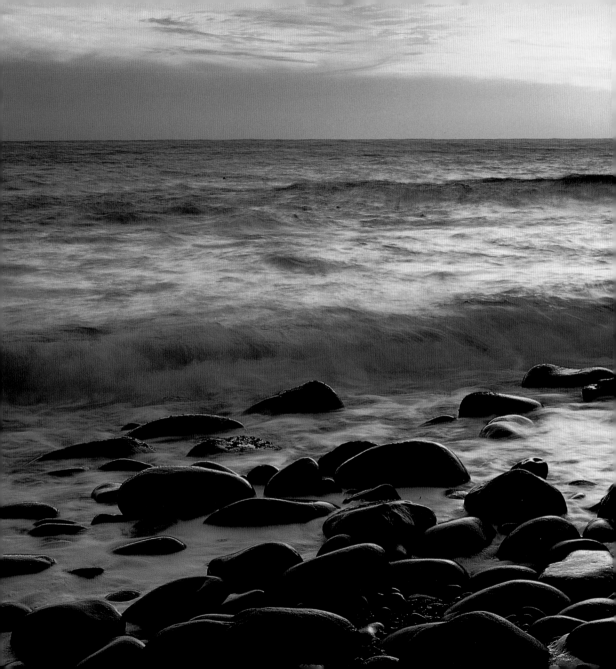

"Over all, rocks, wood, and water, brooded the spirit
of repose, and the silent energy of nature stirred the soul
to its inmost depths."

— Thomas Cole, *Essay on American Scenery*

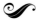

Sunset, near Trinidad

"Nature teaches more than she preaches. There are no sermons in stones. It is easier to get a spark out of a stone than a moral."

— John Burroughs, *Time and Change*

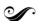

Late afternoon light, Trinidad State Beach

"Where man is not, nature is barren."

— William Blake, *Proverbs of Hell*

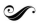

Point Pinos Lighthouse, Pacific Grove

"'Tis true that on the sea is boundless gain. But to be safe, upon the shore remain."

— Sadi, *Gulistan*

Dusk, near Mendocino

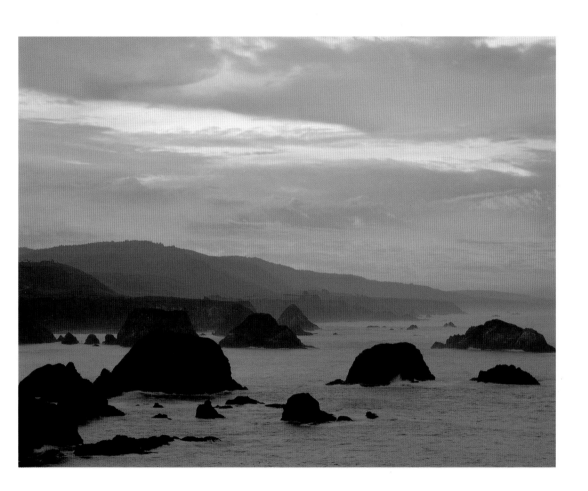

"...within the roar of a surf-tormented shore we can find the beautiful blossoms of the beach-aster."

— Mary Elizabeth Parsons, *The Wild Flowers of California*

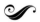

Seaside daisies, northern California coastline

"There is ever a lurking suspicion that the beginning of things is in some way associated with water..."

— John Burroughs, *Wake-Robin*

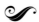

Receding waves, Big Sur Coast

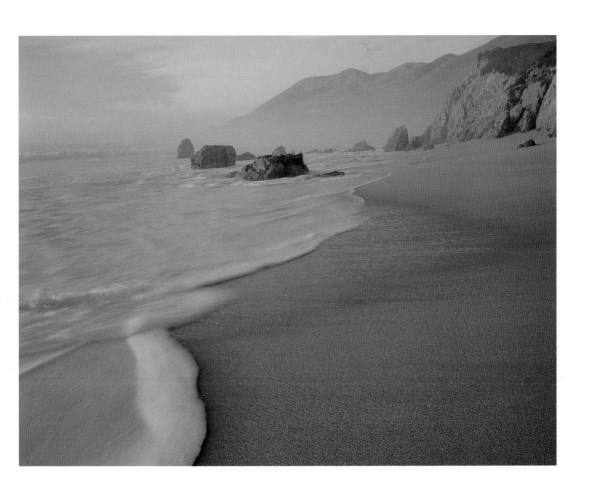

"As a drop of water unto the sea, and a gravelstone in comparison of the sand; so are a thousand years to the days of eternity."

— Ben Sira, *Book of Wisdom*

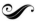

Surf-polished rocks, Monterey Peninsula

Overleaf: Sea stacks, Garrapata State Park

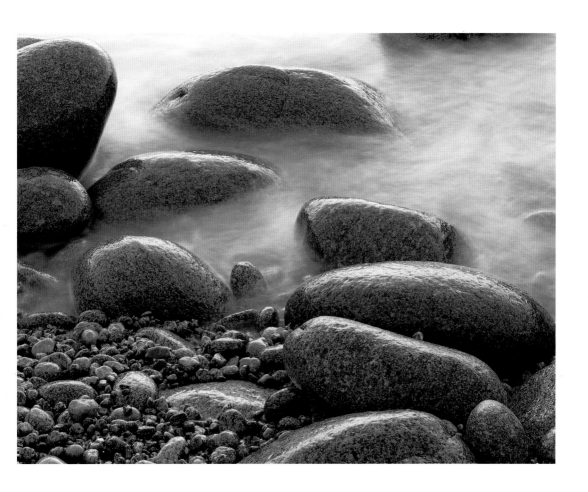

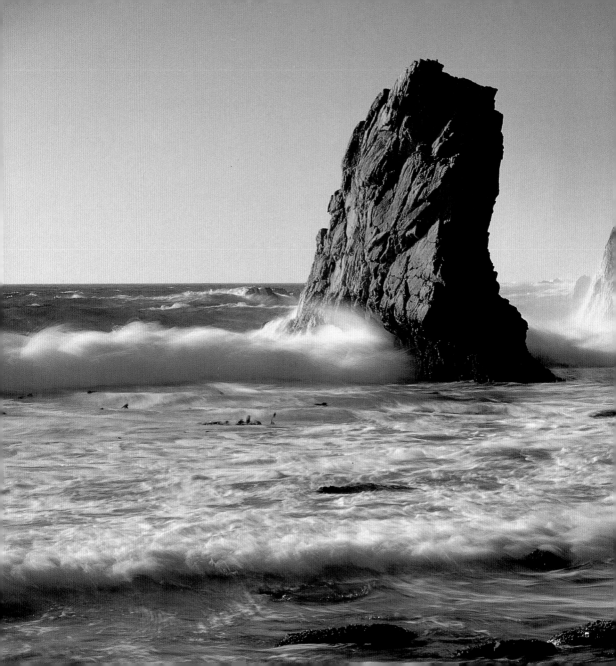

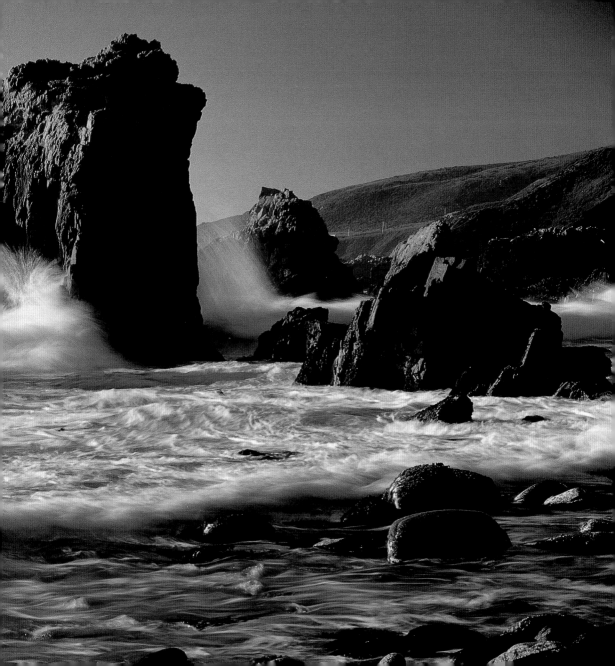

"Seek'st thou the plashy brink...
Or where the rocking billows rise and sink
On the chafed ocean-side?
There is a Power whose care
Teaches thy way along the pathless coast —
The desert and illimitable air —
Lone wandering, but not lost."

— William Cullen Bryant, *To a Waterfowl*

Seabirds, Monterey Bay

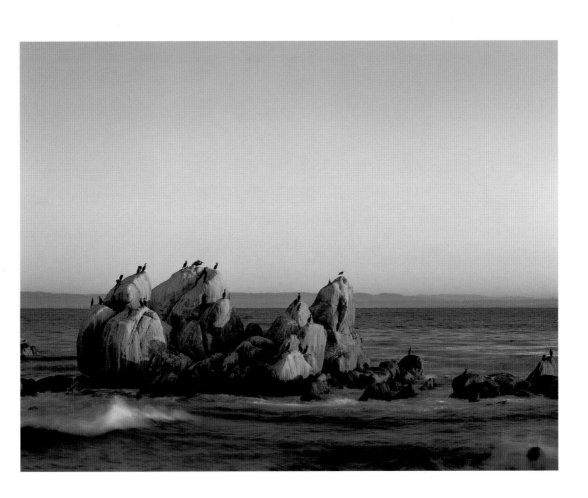

"There is, no one knows, what sweet mystery
about the sea, whose gently awful stirring
seem to speak of some hidden soul beneath."

— Herman Melville, *Moby Dick*

Sunset, near Punta Gorda

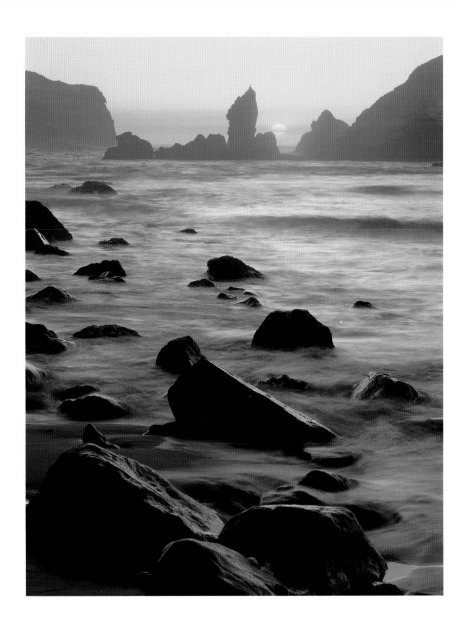

"Like as the waves make towards the
pebbled shore,
So do our minutes hasten to their end."

— William Shakespeare, *Sonnet 60*

Roiling surf, Orange County

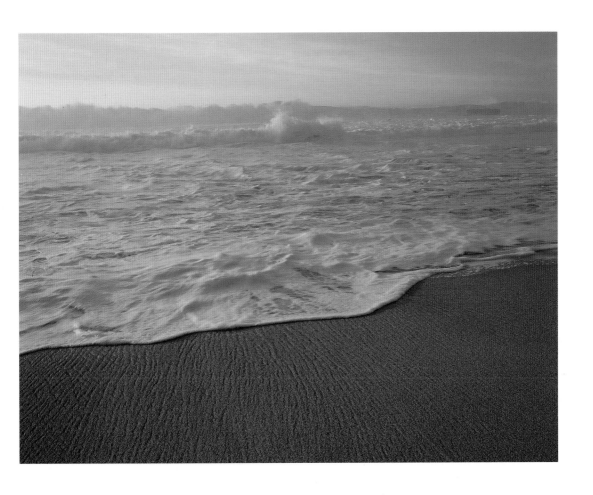

"...to see with your reason as well as with your perceptions, that is to be an observer and to read the book of nature aright."

— John Burroughs, *Ways of Nature*

Calla lilies, Big Sur Coast

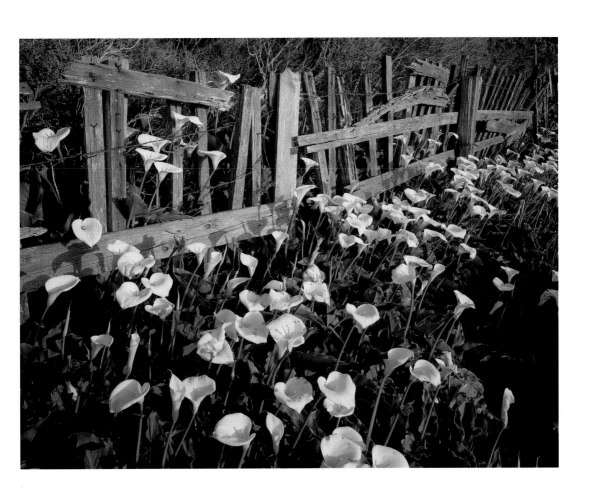

"Great wide, beautiful, wonderful world,

With the wonderful waters round you curled,

And the wonderful grass upon your breast,

World, you are beautifully drest."

— William Brighty Rands, *The Child's World*

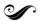

Santa Lucia Range, Monterey County

"The redwoods, once seen, leave a mark or create a vision that stays with you always….The feeling they produce is not transferable. From them comes silence and awe."

— John Steinbeck, *Travels with Charley*

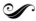

Rhododendron and redwoods,
Del Norte Coast Redwoods State Park

"Everything flows and nothing stays."

— Heraclitus, Plato's *Cratylus*

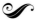

Weathered redwood, Redwood National Park

Overleaf: Sea stacks at dusk, near Punta Gorda

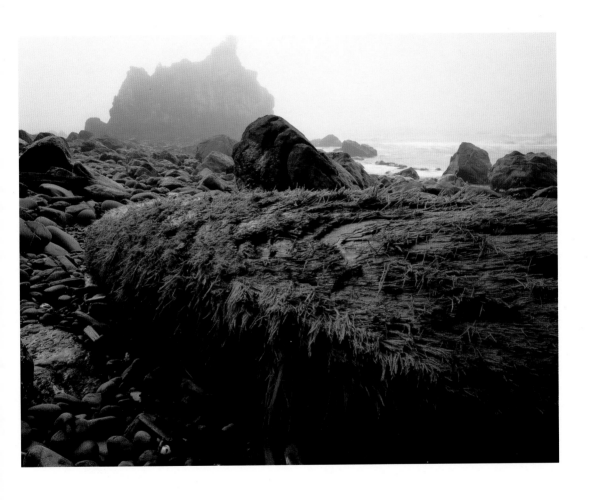

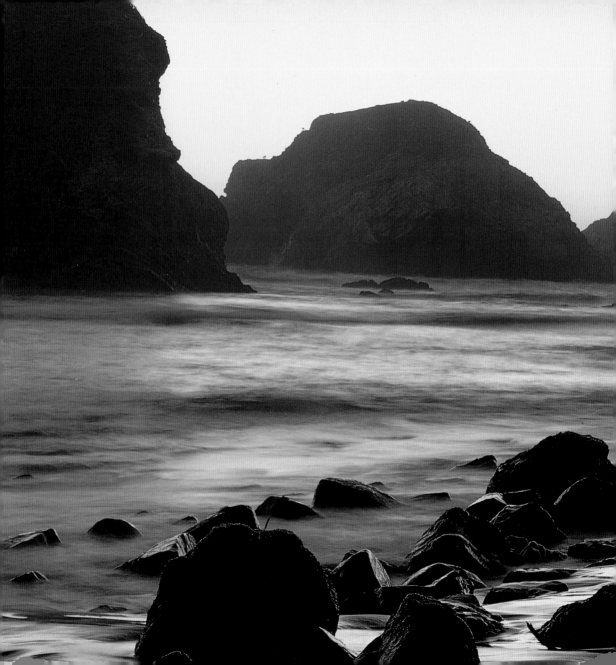

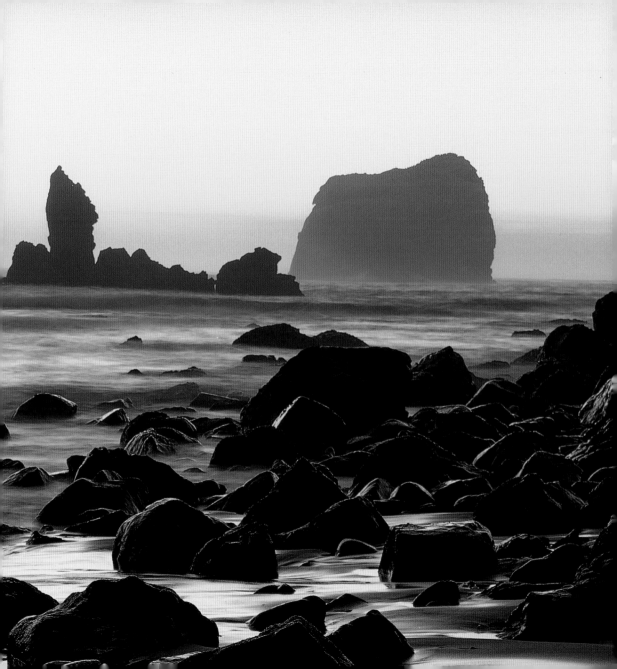

"Southward of this point the shore, composed of low white cliffs,…forms the
north point of a bay extending a little distance to the northward,
which is intirely open, and much exposed….According to the Spaniards,
this is the bay in which Sir Francis Drake anchored;
however safe he might then have found it,
yet at this season of the year it promised us little shelter or security."

— George Vancouver, *A Voyage of Discovery to the
North Pacific Ocean and Round the World, 1791-1795*

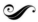

Drakes Bay, Point Reyes National Seashore

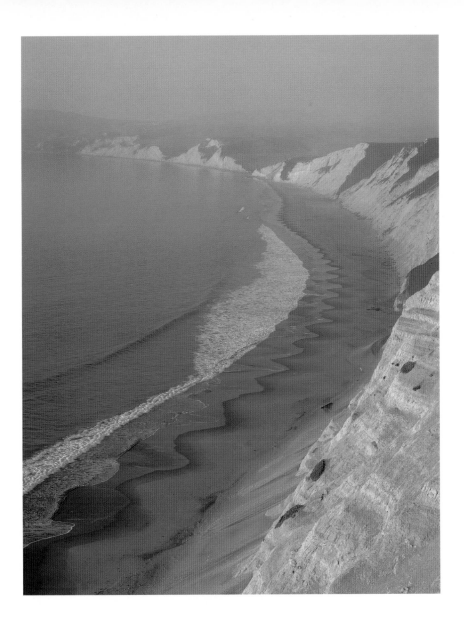

"Wisdom sailes with winde and tide."

— John Florio, *Second Frutes*

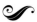

Sailboats, Monterey Bay

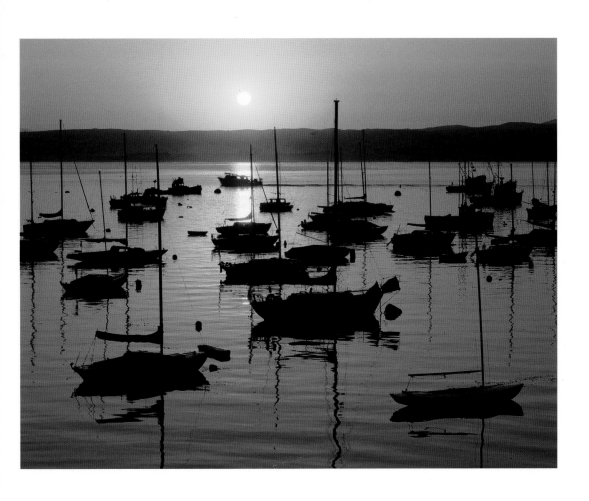

"To us the near-hand mountain

Be a measure of height, the tide-worn cliff at the sea-gate

a measure of continuance."

— Robinson Jeffers, *Night*

Cuffy Cove, near the town of Elk, Mendocino County

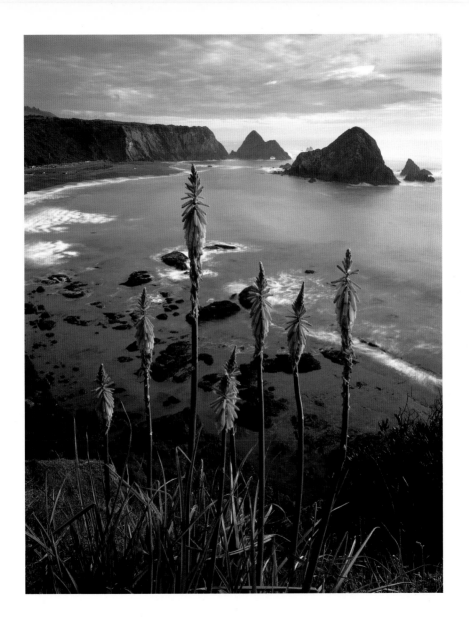

"...To see a world in a grain of sand
And a heaven in a wild flower,
Hold infinity in the palm of your hand
And eternity in an hour."

— William Blake, *Auguries of Innocence*

Sand patterns, Trinidad State Beach

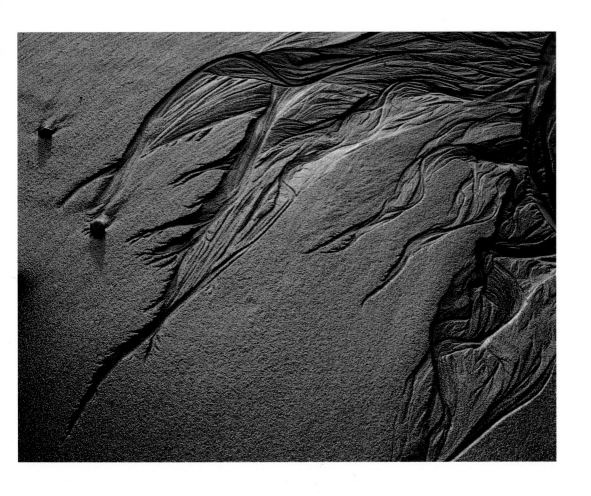

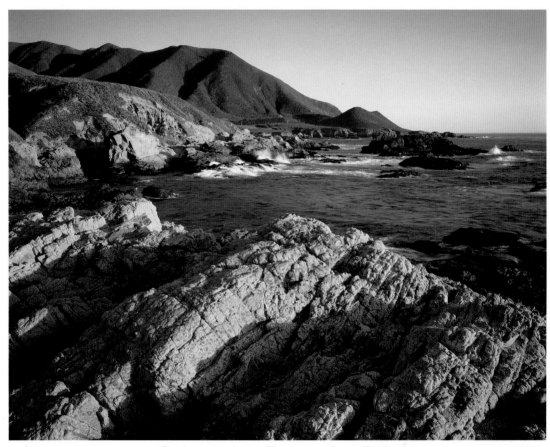

Rocky coastline, Garrapata State Park